DIGITAL
PHOTOGRAPHY

ABOUT THIS BOOK

Digital Photography is an easy-to-follow guide to finding out what digital photography involves, buying a digital camera, taking a photograph, and manipulating it on a PC.

PHOTOGRAPHY BECAME A POPULAR hobby soon after its invention, and for the next 160 years the one feature that remained constant was that all cameras had to be loaded with "wet" film in one form or another. Now, with the development of the charge coupled device (CCD), which converts light waves into digital signals that can be stored as an image, the age of traditional photographic film is coming to an end. This book is intended as an introduction to this rapidly developing technology for anyone who might be attracted to the possibilities but who is unsure about where to begin.

This book is designed for anyone who is taking their first steps into the new world of digital photography.

We start by helping you find out what a digital camera is and how it uses digital technology. The different types of digital camera are described, alongside the technical features that a digital camera contains and the further options that some offer, such as the ability to record short sound and video clips. You'll find advice on what criteria to use when choosing a digital camera and a discussion of the advantages of digital over conventional technology. The advantages that are described show how you can decide immediately after taking a photograph whether to keep or discard it. The different techniques required for taking a digital photograph are described, and you'll also find advice on taking pictures in general.

Once these aspects have been covered, the major advantage of taking digital photographs – being able to load them onto your PC and enhance them as you wish – is then dealt with in detail. A section is devoted to manipulating your images using image-editing software. This gives you a high degree of control over the appearance of the final picture by using techniques such as cropping, changing color levels, and special effects, all of which are described fully. Advice is also given on the different file formats that can be used to save images and on the different means available to store them.

Once you have created and stored your finished photographs, the book concludes with an example of importing an image into another application, allowing you to incorporate it into your own documents, send it by email, or publish it on the World Wide Web.

ESSENTIAL DK COMPUTERS
MULTIMEDIA

DIGITAL PHOTOGRAPHY

ALEX MAY

A Dorling Kindersley Book

Dorling Kindersley
LONDON, NEW YORK, DELHI, SYDNEY

Produced for Dorling Kindersley Limited by
Design Revolution, Queens Park Villa,
30 West Drive, Brighton, East Sussex BN2 2GE

EDITORIAL DIRECTOR Ian Whitelaw
SENIOR DESIGNER Andy Ashdown
EDITOR John Watson
DESIGNER Andrew Easton

MANAGING EDITOR Sharon Lucas
SENIOR MANAGING ART EDITOR Derek Coombes
DTP DESIGNER Sonia Charbonnier
PRODUCTION CONTROLLER Wendy Penn

Published in Great Britain in 2000 by
Dorling Kindersley Limited,
9 Henrietta Street, London WC2E 8PS

2 4 6 8 10 9 7 5 3 1

A CIP catalog record for this book is available from the British Library.

ISBN 075130993 1

Color reproduced by First Impressions, London
Printed in Italy by Graphicom

For our complete
catalog visit
www.dk.com

CONTENTS

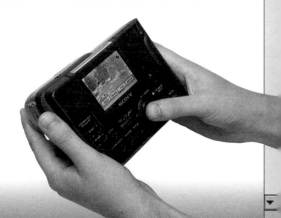

DIGITAL CAMERAS

Digital photography is a fairly recent technological advance, but rising quality and falling prices mean that the new possibilities it offers are becoming increasingly available.

WHAT IS A DIGITAL CAMERA?

All cameras take a picture by focusing the light passing through the lens onto a patch of light-sensitive medium. In the case of a traditional camera, this medium is photographic film – a strip of plastic covered in chemicals that react when exposed to light and record the focused image. In a digital camera, the place of the film is taken by a small chip called a CCD. This reacts to light, just as film does, but instead of storing the image chemically, it converts it into a digital form.

A VERSATILE IMAGE

Once attached to a Personal Computer (PC), the data that makes up this digital image can be passed from the camera to the computer via a cable that links the two. Various kinds of software then allow you to store, change, print, and even email the image.

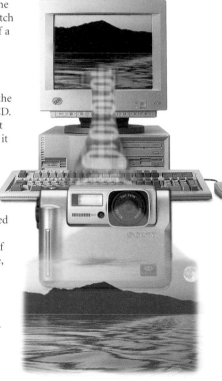

Digital possibilities
Once your photograph is stored as data in your camera, the image can be flowed into the digital world by downloading it to your PC, opening up a whole range of possibilities.

THE VERSATILE DIGITAL CAMERA

Once a picture has been taken, it can be downloaded from the camera to a PC and edited before being viewed and stored. Some digital cameras now available can take short movies that can be viewed on a TV screen.

Storage software
Computer programs can be used to sort your images into an album on your PC.

Color printer
Certain printers can link directly to your camera. Others link through your computer.

Storage device
There are many ways to store your images externally, including floppy disks and external hard drives.

Ram card
Available in different memory sizes, this storage device slots into some cameras to allow more images to be taken.

Digital camera
Once this versatile piece of equipment is attached to a PC, you can open a world of photographic and artistic possibilities.

Personal computer
If you don't already have one, this is an expensive addition to a digital camera, but digital editing and manipulation are impossible without it.

DIGITAL CONSIDERATIONS

Despite the undeniable practical benefits of digital photography, some issues need to be considered.

Cost is the first consideration. Digital cameras are more expensive than film-based ones and, as is the case with all technology, it pays to buy something that will do what you need, rather than opting for a cheaper model that will quickly become obsolete.

To get the most out of your camera, you need a computer. Some stores can print out your pictures, for a price, but to gain the real advantages of a digital camera, you'll want to process the images yourself.

The storage of images is a hidden cost in digital photography. Most cameras use RAM cards with a capacity of between 4–128MB to store images, and you need at least two to make sure that you don't run out of space at the wrong time.

DIGITAL CAMERA EQUIPMENT LIST

There are many attachments that will increase the versatility of your camera, but you can get by with just the basics until you are at ease with the digital technology. A compact camera is probably the best kind to start with.

Camera
There is a large, and ever-increasing, array of digital cameras on the market, varying widely in price and specifications.

Serial cable
This is the cable that connects your camera to your PC and allows you to download the images you have taken.

Audio/video cable
You need this if your camera can record sound and video.

Rechargeable batteries
These will save you money in the long run.

Ram or Flash card
This provides extra memory to store images.

WHY GO DIGITAL?

Digital photography has many advantages over using a traditional film-based camera. Once you've made your initial investment, you're not tied to buying endless rolls of films and paying to have them developed. In fact, you can retake pictures until you're satisfied with the results and, once the images are transferred onto your computer, you have all the power of a professional darkroom at your fingertips ready to fine-tune, completely change, or combine the pictures that you take. You can then publish your images on the World Wide Web, send them via email, use them as your desktop wallpaper, print them out, or even compile a photo-CD, to name just a few possibilities.

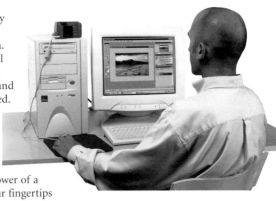

On-screen darkroom
Digital images come into their own on the PC, where you can manipulate them to achieve precisely the look you want before printing or saving them.

BUYING TIPS

1 Decide what you're going to be using your digital camera for. This is a crucial step.

2 If you buy something that's cheap, but doesn't have the features you need, you'll have wasted your money.

3 One that has hundreds of features that you're not going to use will cost far more than necessary.

4 Choose a camera that is a little bit more advanced than you think you'll need, and one that can be upgraded easily.

5 Read through the first section of this book to get an understanding of what all the important parts of a digital camera are.

6 Be cautious when asking advice from people who sell digital cameras. Many digital cameras have very impressive-sounding specifications on which sales staff tend to concentrate, but at the end of the day it is image-quality that is the most important factor.

7 Read magazine reviews, and especially roundups that compare several of the latest cameras. These will help you make the right choice for you.

INSIDE A DIGITAL CAMERA

From the outside, digital cameras generally resemble normal film-based ones. There is a lens, a viewfinder, a shutter-release button, and a flash.

However, lying beneath the gleaming exterior there are some very significant differences. Firstly, the light-sensitive surface at the back of the camera is a small flat CCD panel. This converts the received light into digital data, and the camera contains the means of storing this, either on an inbuilt card or a removable disk. Secondly, some cameras also have an LCD display panel on the back. This is used to preview pictures before they are taken, and to review stored images.

PARTS OF A DIGITAL CAMERA

1 Shutter release
The button you press to take a picture. Most shutter releases can be pushed down halfway to lock the focus and check that there is enough light for taking the picture.

2 Hot shoe
(flash attachment)
A flash attachment has been a feature of cameras for many decades and the arrival of digital photography has not dispensed with this accessory. The CCD in a digital camera needs adequate light levels just as the film in a film-based camera does.

3 Red-eye reduction light
A small red light that comes on just before using the flash and helps to reduce the optical effect known as red-eye.

4 Optical viewfinder lens
This is a small lens that passes light through to the optical viewfinder at the back of the camera so you can see the image that will be taken.

5 CCD
This is a small light sensitive chip that is the key technology behind digital photography. Light that passes through the lens barrel is focused onto it.

6 Memory card
This is a thin card that contains memory chips where the images that you take will be stored inside the camera.

7 Batteries
Digital cameras generally use a great deal of battery power, especially if you use the LCD screen for a long time.

8 Optical viewfinder
You look through this window to line up your image.

9 LCD display
Much like the screens found on notebook computers, albeit a lot smaller, the LCD display can be used for previewing the picture you're about to take and for reviewing images that have been stored on the memory card. The model shown here has a fold-out screen, shown in the picture opposite (bottom right).

10 Lens barrel
It is through this tube that the light from the image you are taking enters the camera. It contains a series of lenses that focus the light from the object onto the light-sensitive area, which in this case is the CCD.

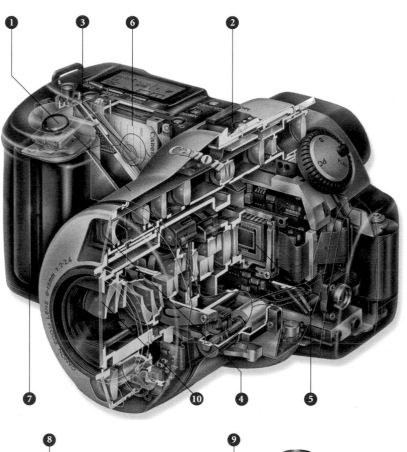

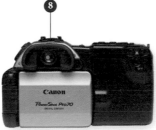

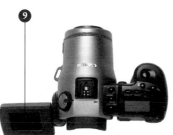

16 Storing Images

18 Optical viewfinder

19 LCD display

TYPES OF DIGITAL CAMERA

The design of a film camera is restricted by the need to have the film cartridge located in one half and a spool in the other so the film can be wound on behind the lens every time you take a picture.

Digital cameras still need to pack in a fair amount of technology but don't have this restriction and so the design tends to be more varied. The three main types of digital camera available are:

Pocket-sized
This compact camera has a 3x zoom lens, a resolution of 1280x960, and a SmartMedia card.

ROTATING
Some digital cameras have the lens mounted on one half and the controls and LCD panel ◻ on the other. This allows the lens to be rotated through more than 270 degrees. You can hold the camera above your head, over the top of a crowd for example, and still be able to frame the shot using the LCD screen.

COMPACT
These range from traditional cases to pocket-sized designs. The camera size is determined by the size of batteries it uses and the image storage system used.

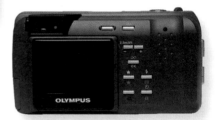

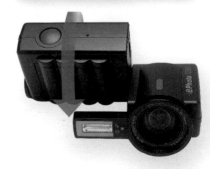

View and review
As well as a 3x zoom lens, SmartMedia card, and a resolution of 1280x960, this camera has an LCD that can be rotated separately from the lens.

| 19 | LCD display |

SINGLE LENS REFLEX (SLR)

SLR cameras have a mirror that allows the optical viewfinder to look through the main lens. With some digital cameras this means that the LCD panel ▯ cannot be used for previewing. This kind of camera offers professional quality, but at a price far above that of simpler models.

Professional quality
This digital SLR is a traditional camera, able to take a full range of lenses, made digital by the addition of a CCD (with a resolution of 1268x1012) and electronic image storage.

COMPARING CAMERA TYPES

1 The design of a digital camera does little to limit its features, although the layout of the buttons and controls is sometimes less than ideal.
2 For example, if you usually look through a viewfinder with your right eye, an LCD panel on the left may be pressed against your nose.
3 A compact camera will feel the most familiar for anyone used to taking

pictures with a film-based camera. All the controls tend to be to hand and the layout is as you would expect, apart from the LCD display on the back.
4 Rotating cameras have the advantage of being able to take photographs where other cameras cannot. The rotating lens is more than just a gimmick, and it can prove useful, but these cameras tend to cost more than a compact design.

5 The benefits of having an SLR system on a digital camera remain debatable. On a film-based camera, where you're totally reliant on the optical viewfinder for lining up your shot, the advantages are clear. For a digital camera, however, where the SLR can disable the LCD panel's ability to preview your shot, you may be losing out on a very useful feature.

▯ **19** LCD display ◁ **14** CCD resolution

THE CCD CHIP

CCD RESOLUTION

The heart of the digital camera is the charge coupled device (CCD). This is a chip that converts light into a digital signal. Its surface is divided up into tiny squares called pixels, each of which records one small segment of an image. The more pixels a CCD has, the more detail it can record. Higher resolutions add to the cost of a digital camera and also increase the amount of data the camera needs to store, and it may be that you don't need the highest quality available. Your choice should be based on what you intend to use the camera for. Web page graphics and holiday snaps don't require much higher than a 640x480 CCD, while images for use in magazine artwork are going to need 1600x1200 or higher.

CONFUSED?

The biggest confusion comes from referring to images as having dimensions. A digital image only has a resolution, not a size. An image composed of 640 pixels by 480 pixels can be displayed on a monitor that has 1600x1200 pixels, but as the image contains less information than the monitor can display, each pixel in the digital image will be spread over several pixels on the screen, resulting in blocks of color that produce a mosaic effect. It is therefore important, when buying and using a digital camera, to consider how you intend to display the image you create, especially if you're intending to print your images out at some point. You will always be limited by the maximum resolution of the CCD in your digital camera, which at 640x480 will inevitably produce images that are of poor quality if printed larger than a snapshot.

RESOLUTION OF THE DISPLAYED IMAGE

Resolution is expressed in different units depending on how the final image is displayed. It is given in pixels, on computers, and in dots per inch (dpi) when printing. Both describe how many small squares of color fit into a certain space. On a computer monitor, for example, a resolution of 1600x1200 means that the screen displays 1600 pixels across by 1200 pixels down. Printers and scanners generally give just one measurement – the dots per inch. A 300-dpi printer can print 300x300 (90,000) dots per square inch.

In a low resolution image displayed at this size, the individual squares of color are visible.

At the same size, a high resolution image is much clearer and contains more detail.

STORING IMAGES

Once the image has been exposed onto the CCD, the camera needs to take the digital information and store it somewhere so the next image can be taken. The preferred method is to use RAM (Random Access Memory) cards, which can record data at a high rate and can store many images, but they tend to be expensive.

FLOPPY DISKS

While the majority of cameras use RAM cards to store images, a few have a disk drive built into the camera and use regular floppy disks. The storage capacity of floppy disks is limited to 1.44MB and therefore very few images of any quality can be stored on each one. Floppy disks are also extremely slow, when compared to RAM cards, but they do have the advantage of being very cheap.

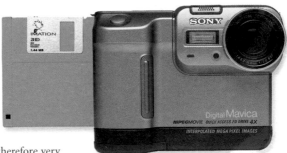

This Sony floppy disk camera employs the simplest method for transferring your photographs to a PC.

DIGITAL INFORMATION

The form in which the images are stored is called digital because the data is literally composed of digits – the zeros and ones that constitute the binary language in which computers operate. Each individual unit of digital information – either a 1 or a 0 – is called a "bit," and the larger the amount of information of which an image is composed, the more bits it consists of.

The number of images that a disk can store therefore depends on the capacity of the disk and the amount of information that makes up each image. The higher the resolution of the CCD in the camera, the larger the size of the digital file that it creates when you take a picture.

As a "bit" is a very small unit of information, the sizes of files, storage disks, and computer hard drives are referred to in much larger units that express the number of bytes (1 byte = 8 bits) in thousands, millions, and billions. The commonly used units, which are useful to know, are shown on the opposite page.

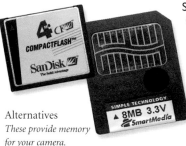

SMARTCARDS AND COMPACT FLASH CARDS

Although a few digital cameras use floppy disks to store images, RAM cards are more common. SmartCards are memory cards about the size of a large postage stamp that can be plugged into a portable computer via a converter. Compact Flash Cards are an alternative. They are larger and can also be plugged into a portable computer.

Alternatives
These provide memory for your camera.

UNITS OF SIZE AND CAPACITY

Files, memory, and disk space are referred to in terms of kilobytes, megabytes, gigabytes, and even terabytes (for really huge computers only!).

1 byte = 8 bits
1 kilobyte (KB) = 1024 bytes
1 megabyte (MB) = 1024 kilobytes (1 million bytes)
1 gigabyte (GB) = 1024 megabytes (1 billion bytes)
1 terabyte (TB) = 1024 gigabytes (1 trillion bytes)

DOWNLOADING IMAGES

Once your photographs are stored on RAM cards, in most cases you'll need to download them to your computer. When you buy a digital camera, the package will contain a program for downloading images, and may also include TWAIN driver software (standing for "Toolkit Without An Interesting Name"). After downloading the images from the card, you can erase the data from the card and reuse it. Card readers and adapters are available to increase the rate at which you can download images.

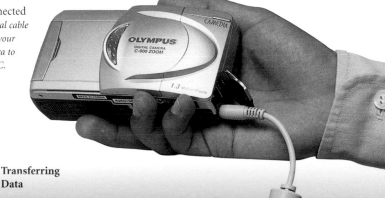

Connected
A serial cable links your camera to the PC.

39 **Transferring Data**

THE VIEWFINDER

Digital cameras generally have two viewfinders. One is optical – the same as that on a film-based camera – and you look through this to compose your shot.

The other is a battery-driven digital LCD (Liquid Crystal Display) panel. This also helps you to compose your photograph, but it has additional functions, too.

OPTICAL VIEWFINDER

The optical viewfinder uses a system of lenses to show you, through the small window at the back of the camera body, a representation of what the CCD is seeing. On a camera that also has an LCD, it allows you to view the scene you are photographing without having to use up battery power.

The major drawback with optical viewfinders is that they don't accurately show the edges of the image you are about to take. Since the main lens and the viewfinder lenses are in different places on the front of the camera, the viewfinder sees a slightly offset version. This is why SLR was created – it allows the viewfinder to look through the main lens, giving an

The optical viewfinder guides

accurate view of what will be exposed on the film. To compensate for this, there are often translucent guidelines drawn inside the viewfinder that show the edges of the frame that the main lens will see. While this still isn't as accurate as having SLR, it does enable you to frame the shot properly without cutting off the tops of people's heads 📄. The other disadvantage, especially on digital cameras, is that you often cannot see how light or dark the CCD thinks the image is. This can result in very washed-out or dark, bland pictures that will need a lot of work in an image-editing program 📄 to improve. Because of this, some digital cameras don't have an optical viewfinder at all and instead rely on the LCD panel for previewing and framing images.

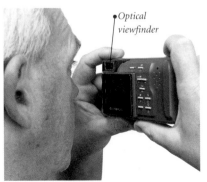

•*Optical viewfinder*

📄 **27** Framing the image

📄 **40** Image Editing

LCD DISPLAY

The LCD display on the back of a digital camera uses technology identical to that of a laptop computer screen. Consequently, the display suffers from the two principal problems of laptop LCD screens: the difficulty of seeing their display when the ambient light is very bright, and high power consumption. However, not all LCD screens are created equal. A few are extremely clear and bright under all conditions, whilst others are too dark for you to see the image on a sunny day.

Although using the LCD screen is often preferable to any available optical viewfinder, it does consume battery power and so should be used sparingly.

The main advantage of using the LCD display for framing your picture is that you can see exactly what the CCD sees, including how bright or dark the image will eventually be.

The LCD display also allows you to access the hidden features of your digital camera. Most come with an onscreen menu system, but whilst some have thoughtfully designed graphics, others provide only very basic symbols. However, all designs enable you to select between different resolutions, image-compression settings , whether to use the flash or not, and also to activate various special features such as panoramic mode or recording sound and video clips.

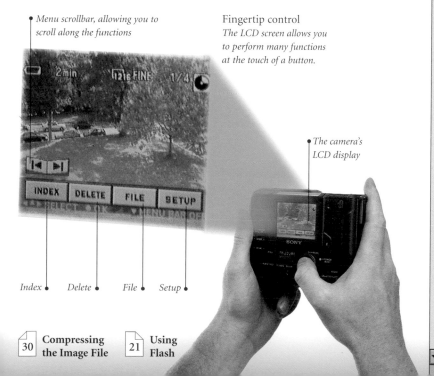

Menu scrollbar, allowing you to scroll along the functions

Fingertip control
The LCD screen allows you to perform many functions at the touch of a button.

The camera's LCD display

Index *Delete* *File* *Setup*

Compressing the Image File 30

Using Flash 21

FEATURES

Digital cameras generally come with a very wide range of features, compared to their film-based counterparts. Here we introduce the most common features.

AUTOMATIC EXPOSURE

In order to record a picture, a camera needs an adequate amount of light reflecting from the subject, passing through the lens, and onto the light-sensitive medium behind the lens, be it film or a CCD. Most digital cameras automatically ensure the correct exposure by adjusting the aperture, through which the light enters the camera, or the time for which the CCD is exposed to the light.

GETTING IT RIGHT

Automatic exposure control works well in situations where the levels of light are fairly constant across the scene. In the example below, the first image shows the effect of underexposure, while the second shot has been overexposed. In the third image, the camera has automatically controlled the exposure.

When the light varies widely across the scene to be photographed, it may be best to use fill-in flash or exposure lock .

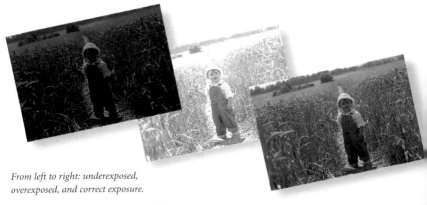

From left to right: underexposed, overexposed, and correct exposure.

 21 **Fill-in flash**

 34 **Exposure lock**

USING FLASH

Most digital cameras have a built-in flashgun and some have an additional "hot shoe" for a more powerful flashgun to be attached when more light is needed.

Built-in flashguns generally have three settings: automatic, on, and off, and this is controlled from a switch on the camera body or through the LCD menus.

CONTROLLING THE FLASH

Most people leave the flash set to automatic all the time. When you half press the shutter button, the camera measures the light and shows whether or not the flash is necessary.

With the setting at "on", the flash always operates, and the camera adjusts the exposure to compensate. This is useful if the main subject is near you, but where the main subject is further away, using the flash results in an underexposed image.

Without flash, the subject is too dark.

FILL-IN FLASH

If the background is bright but the subject of your photograph is not, the camera may be fooled into judging that flash is unnecessary. The result will be a dark main subject with an overexposed background (see above). To remedy this, use a technique called fill-in flash. Set the flash to "on" and it will "fill in" the dark foreground with light, illuminating your subject and adjusting the exposure to compensate for the background light.

Fill-in flash illuminates the subject.

OPTICAL/DIGITAL ZOOMS

A zoom allows you to focus into a smaller part of an image giving the effect of moving closer to the subject. Almost all digital cameras have either an optical zoom or a digital zoom, and some have both. The power of a zoom is measured by the number of times it can enlarge a section of the image – a "2x" zoom has the effect of doubling the size of an object.

Having a zoom on a camera allows you to get closer to the action, especially when you can't physically move any closer to your subject. It can also help you to frame the image more interestingly .

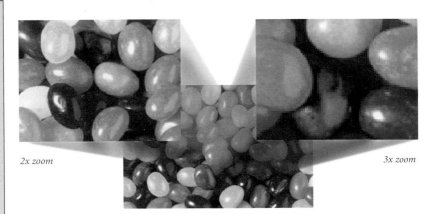

2x zoom

3x zoom

Image without zoom

OPTICAL ZOOM

Optical zooms have only recently started to appear on digital cameras – most zoom features on digital cameras merely enlarge a cropped area of pixels to simulate the effect of a telephoto lens. An optical zoom works by physically adjusting the distance between the lenses within the camera. This means that you can zoom in as little or as much as you need within the limits of the lens, although the greater the zoom, the less light reaches the CCD.

The optical zoom lenses found on digital cameras aren't generally very powerful, but they are still very useful. Older cameras rely on a manual lever to slide the lens in and out, but some cameras now have an electrically operated optical zoom that is controlled by the push of a button. This makes it easier to zoom in and out by small increments and get the framing just right. On the downside, this innovation means that the camera draws energy from its batteries at a faster rate.

DIGITAL ZOOM

An optical zoom enlarges an image by magnifying a part of the subject, and the same effect can be synthesized digitally by creating the digital image from a smaller area of the CCD. Digital zooms generally have a much higher power rating than their optical counterparts, but the quality of your images will become lower and lower the more you zoom in.

This is because, whereas an optical zoom focuses part of the subject on the whole of the CCD and records more information about that part of the subject, a digital zoom provides you with a small part of the total subject without recording more information about it. The more you zoom in on a subject, the less information there is available, and this results in a lower resolution image.

This effect is most apparent with those digital cameras that automatically reduce the image resolution as you apply more digital zoom. On the whole, a digital zoom is not really very useful. It compromises image quality to such a large degree that you'd probably get better results by taking the image without it and then enlarging the section of the picture you're interested in with an image-editing package ◻.

RED-EYE REDUCTION

Using a flash can generate an effect known as red-eye. This occurs when the subject is looking directly at the camera lens and is caused by the light from the flash passing through the pupil of the eye and reflecting off the retina straight back to the camera.

IN-BUILT SOLUTION

Most cameras with a built in flashgun now overcome this problem by having a red-eye reduction flash. This produces a small flash just before you take the picture, causing the pupils of your subject's eyes to contract before the main flash goes off, thus reducing the amount of light that can be reflected back.

Red-eye reduction flash would have eliminated this effect

Image Editing

MACRO MODE

Another very common feature in digital cameras is macro mode. This allows you to get extremely close up to your subject – often within a few inches. While a human subject may find this quite disconcerting, it's ideal for taking pictures of small wildlife and flowers. Although you may not find yourself using macro mode very often in traditional photography, in the digital world the image you take need not be the final picture. You can use macro mode to build up a collection of clip art for use within documents or even within other pictures. Here are a few ideas:

If you come up with a new logo design, scribbled on the back of a napkin, just take a picture using macro mode and email it back to the office

You can use a picture of your signature to "sign" your word-processed letters

Taking parts of pictures

This picture contains three images together: the happy couple, wine glasses, and balloons. The glasses were taken using macro mode, and by combining this with the other elements an imaginative fantasy feel has been added to an otherwise ordinary image.

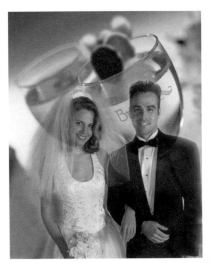

SOUND/VIDEO

Some digital cameras even allow you to record short sound and video clips. Although this can rapidly fill your camera's memory, reducing the number of images you can store as well as draining the batteries, these cameras can be useful tools when a static image just wouldn't fully capture the moment.

SHORT BUT SWEET

Recording a few seconds of sound at the same time as taking an image can be used effectively when presenting your pictures in a slide show. Ambient background noise that matches your images can be played in a loop to help bring your picture to life. Sound clips are generally stored in WAV format and can be transferred to your computer at the same time as your stored images. Video clips are generally very memory-hungry and, as such, should be used sparingly. Since a digital camera's prime purpose is to take static images, the video support is generally fairly limited. You won't be able to use a very high resolution – 160x120 or 320x240 are normal – and you'll probably be limited to 10 or 20 seconds of recording time. This may sound restrictive but at a wedding, for example, you could record a short video of the key moments. Video clips can be stored in AVI format (which is uncompressed and gives the highest quality but only allows you to record very short clips), or MPEG (which is a highly compressed format giving longer recording times but with a consequent loss of image quality).

TECHNIQUES

Most cameras will take reasonable pictures if you just use the "point and click" approach, but learning a few basic techniques can help you to improve your images dramatically.

COMPOSING THE PICTURE

Digital photographers know that pressing the shutter release is only the first step to a finished image. The key is often not to try to take a finished picture but to record a source image that can be adjusted later to produce a finished photograph.

PREVIEWING
Having a digital camera affords you the luxury of being able to see your pictures straight away and decide whether or not to keep them, without wasting film or money. The ability to preview the shot you have just taken also enables you to learn quickly what you are doing wrong – and what you are doing right! Make a point of studying the preview images to check that the lighting is correct, the composition of the picture works, that it doesn't contain unwanted elements, and that you haven't cut off a vital part of the subject.

You will soon find yourself producing photos with far greater power and impact.

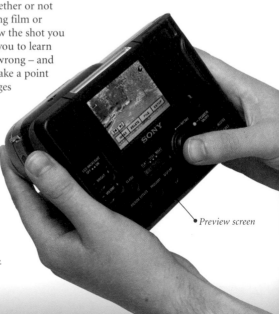

• *Preview screen*

Instant editing
An LCD display allows you to decide whether an image should be stored or retaken straight away.

BACKGROUND OBJECTS

For most people, the best way to improve the quality of their pictures is to spend a little longer over composing the shot and checking that the lighting conditions are right. However, by taking a little more time to examine the scene, either on the LCD display or directly, you will notice details that would have escaped you previously, such as distracting objects in the background. Here an electric fan behind the subject spoils the composition of the picture.

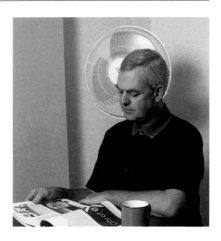

FRAMING THE IMAGE

One of the main pitfalls for the amateur photographer is incorrectly framing the shot. It can be all too easy to focus on a person's face and not notice you've chopped their feet off or, even worse, missed out the top of their head. In the example shown here the photographer has concentrated on the detail and lost the top and bottom of the monument. Try to leave room around your subject – possibly even a little more than you would leave using a traditional camera. This can easily be corrected later, once you have the image on your PC and are cropping ▢ the picture. On the other hand you don't want to waste space either. If your image has just one subject, try to fill most of the frame with it. If it is impossible to fit everything in, then take several pictures. On the PC you can combine two or more separate images and control the final composition at that stage rather than making the camera do all the work.

46 Cropping

CHOOSING THE RESOLUTION

As we have seen, resolution ⬚ is the measurement, in pixels, of an image. Even though the CCD limits the overall resolution, most digital cameras offer a selection of lower settings. It's important to select the correct one depending on what the resulting image is going to be used for. If you intend to use an image on a Web page then you can probably get away with the lowest resolution.

Low resolution image

Medium resolution image

IMAGE USE

Although the CCD of a digital camera limits the maximum resolution of the images you can take, most will offer you the ability to use a lower image resolution. The choice of which to use depends on what you eventually intend to do with the image. A low resolution image will look terrible when printed out as a poster, but using the highest resolution for a picture destined for the Internet is nothing short of overkill!

**Resolution of the
displayed image**

LOW RESOLUTION IMAGES BELOW 800X600 PIXELS

Web pages, in particular, generally consist of images smaller than 640x480, making this resolution ideal for pictures destined for the Internet. The main drawback with these images is that if you intend to print them out they will appear fairly small, unless you stretch them, which makes them appear very blocky. You're also not going to capture any fine detail in your image.

MEDIUM RESOLUTION IMAGES 800X600 – 1280X1024 PIXELS

Images in this range take up more memory, take longer to process but reward you with much higher levels of detail and more flexibility in terms of what you can do with them.

HIGH RESOLUTION IMAGES ABOVE 1280X1024 PIXELS

When it comes to printing your images, especially on a large scale, you'll need to use the highest resolution your camera has to offer. While you may only be able to store a few of these mammoth-sized files on a RAM card, their detail levels are very high. By turning off all image compression ⌐, if your camera supports this feature, you can obtain even higher levels of image quality but with a sizeable increase in file size. Not only can you store very few images of this size, they also take an age to transfer over a serial link. If you plan to be working at this quality often then make sure your camera comes with a USB ⌐ connection and get several large capacity RAM cards – you're going to need them!

High resolution image

30 Compressing the Image File

38 Other Forms of Connection

COMPRESSING THE IMAGE FILE

For each pixel in an image there are generally 24 "bits" 💾 of information. Eight of these record the level of red light in that single pixel, eight record the level of green, and eight record the level of blue.

The number of possible combinations that the 24 bits can express gives a total of 16 million different colors for each pixel. This level of subtlety is far greater than the human eye can appreciate.

COMPROMISING

While storing 24 bits of data for each pixel gives the best possible color quality, it also generates an enormous amount of information. For example, a 1024x768 image would be a file of almost 19 million bits, or just under two and a half megabytes. Since the maximum available resolution is only going to get higher, digital cameras use a process known as compression to reduce the size of the image file down to a manageable size before it is stored. While this dramatically increases the amount of pictures you can store on each memory card, there is a trade off in quality. The more you compress an image, the larger the amount of information you lose, and if you use very strong compression, you can start to see the effect in the form of "banding."

Compressed

Non-compressed

TYPES OF COMPRESSION

There are two forms of compression. The first kind preserves accuracy but does not save a lot of space. The other, used in digital cameras and file formats such as JPEG and MP3, saves far more space, but is called "lossy" compression because it loses information during compression. This isn't as bad as it sounds, since the eye cannot actually see the difference between the 16 million colors that a digital camera can record. When the image is compressed, the camera scans across the picture looking for pixels that are nearly the same and bands them together as one color. The more compression you apply, the more pixels get approximated to the same color, until they start to form solid bands – hence the term banding.

CONSIDERING LIGHTING

Lighting is one of the most critical factors in good photography. Inadequate lighting can be overcome using flash if the subject is at close range, but too much light can be as much of a problem as too little. If the sky is sufficiently bright, well-lit shade may be better than open sunlight, and an overcast sky can actually be an advantage . When light levels are very low – at dusk or even at night – a long exposure can produce dramatic effects, especially if you can capture movement . Compensating by using artificial light indoors can result in unnatural colors .

FACING THE SUN
When taking a portrait on a bright sunny day, many people position their subject facing the sun to make sure he or she is well illuminated. This is understandable, but it has the side effect of causing the subject to squint into the sun. Direct sunlight is also very bright and hard, resulting in harsh shadows on your subject's face.

IN THE SHADE
One solution is to put your subject into a shady area where they will be lit by skylight rather than direct sunlight. This gives a good diffuse lighting and no hard shadows, resulting in a better looking picture. Another solution is to try and take pictures when the sun is low in the sky: either in the early morning or in the late afternoon.

| 21 | Using Flash | 32 | Diffuse lighting | 32 | Low light levels | 32 | Indoor lighting |

DIFFUSE LIGHTING

Although you may not think so, an overcast day is actually better lit – for photographic purposes – than sunlight. The light is diffused as it passes through the clouds, giving everything a softer, more even illumination. Unfortunately an overcast sky is also a rather boring subject, appearing as a flat white area, so try and get as little sky as possible in your picture.

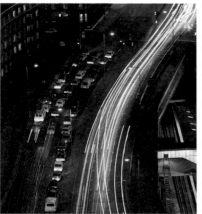

LOW LIGHT LEVELS

There's no need to stop taking pictures after the sun has gone down. If you have a tripod, and a little patience, you can get some great pictures. You'll need to steady the camera because of the longer exposure times – to allow enough light to pass through the lens – but if you don't have a tripod, you can rest the camera on top of a car, a tree stump or whatever else happens to be around.

Fog and mist can add an ethereal feel to landscape pictures. The lighting is soft and diffused, giving good all-over illumination if you use a long exposure but, again, you'll probably need a tripod.

INDOOR LIGHTING

The light from light bulbs is quite unlike sunlight because they emit a very narrow band of color from the visible spectrum. This results in odd coloration when you are taking pictures indoors. Fluorescent lighting gives an overall green hue to an image, while standard tungsten bulbs make everything look more yellow. Filters that fit over the lens of the camera and cancel out these effects are available, but it may be easier to use flash lighting or to adjust the color later using your image editing software ⃞.

CONTROLLING DEPTH OF FIELD

When focusing on your main subject, the camera actually has a range of focus, in front of and beyond that point. This is referred to as the depth of field. Anything within this field will be sharp in the final image, and the further an object is outside of the field, the more blurred it will be. This effect can be used to your advantage.

Large Aperture
Increasing the size of the aperture reduces the depth of field.

Small Aperture
As the aperture decreases, so the depth of field increases, and more of the scene comes into focus.

ALTERING THE APERTURE

The size of the field of focus depends on the size of the aperture, the adjustable hole behind the lens through which the light passes before it hits the CCD. On many cameras the aperture cannot be controlled, but if it can be you have the ability to shorten the depth of field by increasing the aperture and the shutter speed, or to deepen it by doing the opposite.

SHORT DEPTH OF FIELD

A short depth of field, in which only an object at a specific distance from the camera is in focus can make your main subject stand out clearly, drawing the eye to it. This is achieved by using as large an aperture as possible, which also has the benefit of allowing you to take pictures in relatively low light levels without using a long exposure.

LARGE DEPTH OF FIELD

Using a small aperture will give you a large depth of field. This is ideal for landscape pictures where you want as much depth to your image as possible. It might seem a good idea to use a small aperture all the time, but since you are reducing the light that can pass through the lens, you will need a longer exposure, which means that any moving objects will be blurred.

USING FOCUS LOCK

Some cameras come with the ability to lock focus and exposure while you take a picture. These are both very useful features that allow you more flexibility when composing an image. When using automatic focus and automatic exposure, the camera only looks at a small region at the center of the image to check the distance and light levels of your subject. Sometimes this approach doesn't work. If you are pointing the camera between two people, the camera will focus on the background, which may be further away. Similarly, if the center of the image is very dark or light compared to the rest of the view then the exposure will be incorrect.

1 AUTOMATIC FOCUS

Apart from portraits, the most interesting pictures rarely have the main subject right in the middle of the frame.
• Here the camera, which has automatic focus, has focused on the background foliage in the center of the picture, and the subjects are therefore out of focus.

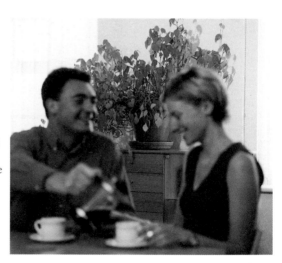

EXPOSURE LOCK

A camera that sets exposure levels automatically can misread the lighting if it varies widely across the view. If the center of the view is brightly lit, then the exposure is reduced, causing dark areas to come out black, and if the center is very dark the opposite will happen. If your camera has exposure lock, it can overcome this. Aim the camera at the subject, press the shutter release button halfway down to lock the exposure, and re-frame the picture before shooting.

2 FOCUS ON ONE SUBJECT

• If the camera has focus lock, move the camera to position your subject in the center of the frame.

• Press the shutter release button halfway down and hold. This locks the lens so that teh camera is focussed at the right distance.

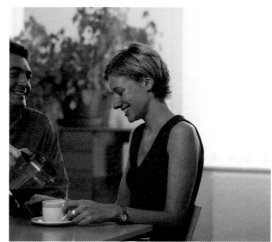

3 RECOMPOSE THE PICTURE

• Now, keeping the shutter release button pressed half-way down, move the camera to re-frame the shot with your subjects as they appear in the original composition.

• This time, the two main subjects appear in sharp focus. It is the foliage in the background that now looks blurred, and this helps to emphasize the figures in the foreground.

ONTO THE PC

Once you've taken pictures and the images are stored on your digital camera, you need to transfer them to a computer before you can do anything further with them.

CONNECTING THE CAMERA TO YOUR PC

Unless your camera uses disks that can be inserted into the floppy drive of your computer, the camera and computer need to be physically linked together so that you can transfer the digital information from the camera to the computer.

CABLE LINK UP
Known as a serial link, a cable connecting the camera to the computer serial port is the option that most manufacturers have opted for. Laptops and some PCs have specially protected serial ports that allow you to connect them while powered up, but check in your computer manual or with your computer manufacturer first. It is generally safer to turn the computer off first, as it is all too easy to touch the wrong pins and damage electronic components inside your computer.

The "serial" port gets its name from the fact that it can only transfer one "bit" of information at a time, building up each single byte by sending eight bits one after the other in a serial manner.

The way in which you do this depends on the connections that each has. The simplest and most common form of connection is by serial cable from a socket on the camera to the serial port in the back of your computer.

The end of the cable that attaches to the computer will probably only fit one port, but if you are in any doubt about which is the serial port, check the manual.

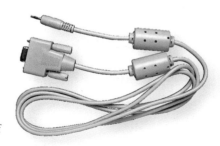

The serial cable connects the camera to the computer.

SPEED OF TRANSFER

As you can probably imagine, sending a stream of bits over a serial link can be quite a slow business. You can transfer about 11K (11 kilobytes) of information every second, which is quite reasonable for small images, but for a 6MB (six megabyte) uncompressed image you'll be sitting around for over nine minutes! Serial technology has been around for many years, and almost all computers support it, which is why all digital cameras include a serial link as their most basic transfer method, although it does require some extra software – supplied with the camera – to transfer the information.

THE FLOPPY OPTION

Another technology that has been around for a very long time is the 3.5-inch floppy disk drive. You may not think there is much space inside a floppy disk, but with today's minute components, some clever designers have managed to come up with a disk-sized device that allows you to plug in your digital camera's memory card 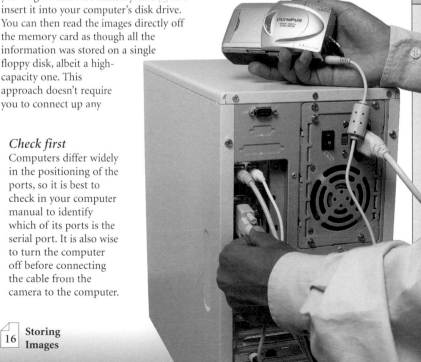 and insert it into your computer's disk drive. You can then read the images directly off the memory card as though all the information was stored on a single floppy disk, albeit a high-capacity one. This approach doesn't require you to connect up any cables between your computer and camera and you don't need any custom software, since the computer regards it as a standard disk. On the negative side, it only supports certain kinds of memory cards, you often need to buy the disk adapter separately, and transfer rates are still not that high.

Check first

Computers differ widely in the positioning of the ports, so it is best to check in your computer manual to identify which of its ports is the serial port. It is also wise to turn the computer off before connecting the cable from the camera to the computer.

16 **Storing Images**

OTHER FORMS OF CONNECTION

If lying on the floor and scrabbling behind your computer with a flashlight trying to plug in the cable from your digital camera really doesn't appeal to you, then you'll be pleased to hear that some computers and cameras support an infrared connection. And if a serial link sounds far too slow, then USB is the technology for you.

INFRARED CONNECTION

This involves merely placing your camera near to your PC and letting the two of them communicate by flashing little lights to each other. You can't actually see the light being sent – it's outside the visible spectrum – but this means that the signal is not affected by house lights being turned on and off. Although infrared ranks highest on the ease of use scale, it essentially works in the same way as a serial link – only one bit (light on or light off) can be sent at a time – and it suffers even worse transfer rates. Furthermore, few computers can receive infrared, and it has not yet been widely adopted for digital cameras.

SPEEDING UP THE TRANSFER

USB (Universal Serial Bus) technology may provide the key to transferring data at a reasonable speed. USB hardware has recently gained industry acceptance and is now included with all new computers.

USB is able to achieve feats that are way beyond the capabilities of the standard serial port. For instance, you can connect more than one USB enabled device into one single port on the back of your computer. In fact you can connect up to 128 devices! You can also connect and disconnect the cables while the computer is turned on and, most importantly, you get much higher data transfer rates.

USB hub

TAKING TECHNOLOGY INTO ACCOUNT

USB, and another similar technology called IEEE 1394, make transferring information from your digital camera even quicker and easier. Few cameras, at the moment, come with USB support, but this will change over time and it represents such an improvement over a standard serial link that it may, and probably should, influence your choice when buying a digital camera.

TRANSFERRING DATA

The software supplied with your camera will probably be dedicated specifically to that make and possibly even model. The software should also have a manual included. This will contain invaluable information on how to download images to your PC, so you should definitely read this thoroughly before starting.

1 INSTALL THE SOFTWARE

• If you haven't already done so, you will need to install the software drivers for your camera onto your PC so the two can talk to each other. This is usually distributed on CD-ROM or floppy disk and will have been included with your camera. The manual that comes with your camera will contain the instructions for installation.

2 DOWNLOAD THE IMAGES

• Depending on the software supplied with your camera, you may now have to run an application to copy the images from your camera onto your hard drive, or, if the software installed TWAIN drivers, you'll be able to import directly into applications. Again, refer to your camera's manual for details of the options that are available to you and how you should go about using them.

IMAGE EDITING

Once your pictures are stored on the computer, you can start to play with them – improving the colors, cropping, combining images – and to do this you will need image editing software.

SOFTWARE

There is a wide range of image editing software, from the simplest programs provided with some digital cameras to the most expensive professional packages. They differ widely in the ease with which they can be used and the complexity of the tasks that they can be used for.

WHICH TO CHOOSE

Your main aim in using image editing software is to achieve good-looking results. Most of the available programs will enable you to carry out basic tasks such as cropping the image to size ⬚, changing colors ⬚, and creating special effects ⬚. If an image editing program was included with your camera, you should try it out to see whether it can do all that you need it to. If you find it too limiting, or if the tools that it offers you are difficult to use, it may well be worth looking at other programs on the market. Read reviews of image editing software in magazines to help you make your choice, and think twice before buying an expensive program.

These images were used to create the picture on page 24 of this book. The image was made of several layers, placed on top of one another.

46 Cropping the image	**50** Color Levels	**54** Special Effects

INTRODUCING PAINT SHOP PRO

In order to show some of the basic editing tasks that can be carried out on digital images, we have chosen to use an image editing program called Paint Shop Pro.

The following pages explain the features of this program, showing you the screen and the toolbar, and taking you through the steps of manipulating various images.

A VERSATILE PROGRAM

Paint Shop Pro has several advantages over many other programs. In the first place, it is considerably cheaper than professional packages such as Adobe PhotoShop, although it is not as comprehensive. Also, you can try Paint Shop Pro out before you buy it, by downloading a demonstration version from the Internet or from a computer magazine cover disk. As well as having many of the features found on the more expensive programs, Paint Shop Pro has its own unique tools that make it stand out in its own right. It also supports the same plug-in format as PhotoShop, so you can access the wealth of third party extensions available. Paint Shop Pro handles all the most popular image formats, and many rarer ones. It also allows you to save images in a completely different format, which is useful for making Web pages, where you want to use a lower quality, more compressed version for the Internet.

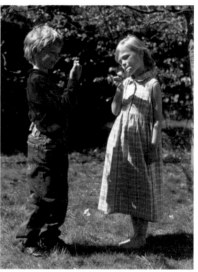

Creating your own effects
Using a sequence of the many features available in Paint Shop Pro, part of this picture has been turned into a grayscale image.

OTHER EDITING PROGRAMS

While Paint Shop Pro is a popular choice for image manipulation, it is certainly not the only one. Windows comes with its own program, called Paint, that can be useful for simpler tasks such as cropping and adding text. You may even get editing software bundled with your camera, such as PhotoSuite or even PhotoShop Limited Edition, a cut-down version but still very useful.

THE PAINT SHOP PRO
WINDOW AND TOOLBAR

With Paint Shop Pro installed on your PC, this is the screen that you see when you open the application. Opening an image file will bring the image into this screen, and it is from here that you can access all the tools that the program offers. These enable you to select an image or part of it, zoom in to look at it in close-up, cut or copy areas of the image, modify the shape and color, remove areas, and add text.

Drop-down menus • *Tool Options* • • *Histogram* • *Tool window*

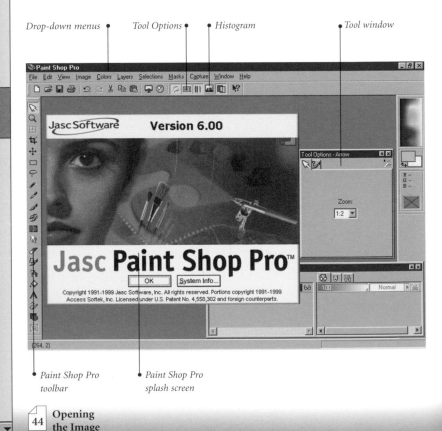

• *Paint Shop Pro toolbar* • *Paint Shop Pro splash screen*

44 **Opening the Image**

THE PAINT SHOP PRO TOOLBAR

1 Arrow
Used to select and move images around.

2 Magnifying Glass
Zooms in and out of an image when you need to do accurate work on a small part of the image.

3 Deformation
Rotates, resizes, skews, or distorts the current layer of the image that you're working on.

4 Crop
Marks out an area of the picture that you want to keep and discards the surrounding information.

5 Mover
Moves the current layer or selection.

6 Selection
Marks out an area shape that can be cut, copied, or modified without harming the rest of the image.

7 Freehand
Like the Selection tool, but you mark out an area by drawing it with the mouse.

8 Magic Wand
Selects part of an image where the color values are almost the same.

9 Dropper
When you click on an image with this tool it picks up the color under your cursor.

10 Paint Brush
Your basic drawing tool. Using the control window you can make it act like a pencil, paintbrush, or much like any other type of marker.

11 Clone Brush
Acts like a paint brush but instead of painting with a solid color it copies and pastes information from another part of the image. The ideal tool for removing unwanted features in your pictures.

12 Color Replacer
Replaces areas of one color with a totally new color.

13 Retouch
Mimics various photographic processes like dodge and burn.

14 Eraser
Rubs out parts of the image.

15 Picture Tube
Draws a set of images, defined in a separate file, as you drag your cursor around.

16 Air Brush
"Sprays" color onto your image.

17 Flood Fill
Fills an area with color.

18 Text
Add text to your image in any available font.

19 Draw
Draws a straight line. and bezier curves.

20 Preset Shapes
Used to draw boxes, circles, and other geometric shapes.

20 Vector Object Selection
Performs a variety of actions on shapes added with the Draw or Preset Shapes tools.

OPENING THE IMAGE

Before you can begin to work on editing an image that is stored on your computer, it must first be brought into Paint Shop Pro. There are two ways in which to do this – through the File selection menu, or by using the built in Browse feature.

1 USING THE FILE SELECTION BOX

• Move the mouse pointer over the File button on the menu bar at the top of the screen and click the left mouse button. A drop-down menu will appear.
• Select Open from the drop-down menu bar by clicking on it.

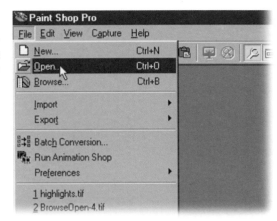

• The file selection box will appear. Click once on the file you wish to open, and a preview will be displayed at the bottom of the box.
• Click on Open to open the file in Paint Shop Pro.

Selected image

The Open button

The Image preview

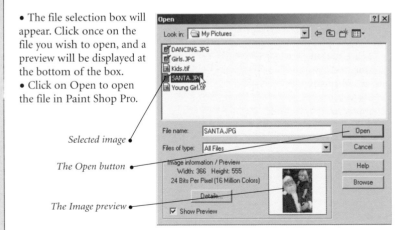

• The selected image will now appear in the Paint Shop Pro window.

The opened image within the Paint Shop Pro Window ●

Keyboard shortcuts
Many of the options that appear in the drop-down menus offer keystroke combinations that avoid the need to use the mouse. For example, Browse can be opened by holding down the Ctrl key and pressing B.

2 USING THE BROWSE FEATURE

• Move the mouse pointer over the File button on the menu bar at the top of the screen and click the left mouse button. A drop-down menu will appear.
• Select Browse from the drop-down menu bar by clicking on it.

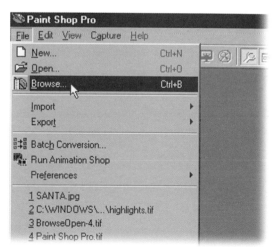

• The browse window now opens showing previews of all the images that are in the current directory. This saves you having to open and close images to find the one that you want.

• Double click on any of these images and it will be loaded into Paint Shop Pro.

"Thumbnail" preview image

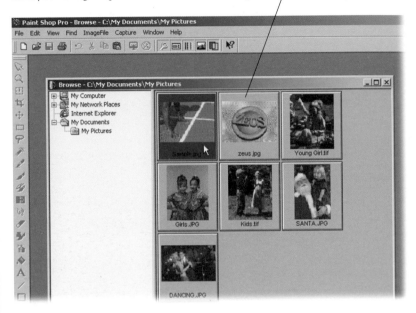

CROPPING

Once you have selected a picture that you want to work on, the first step is generally to crop it to size. This involves selecting a smaller part of the main image to remove any extraneous information from around your main subject. It is at this point that you will see whether you left enough room when you framed your picture 🗋.

Cropping involves marking out a section of the image using either the crop tool or the regular selection methods. Generally, if you just want to remove information from around your main subject, the crop tool is simple and effective. However, by using the selection tool 🗋 you can achieve some interesting effects.

🗋 **27** Framing the image

🗋 **48** Cropping with the selection tool

1 CROPPING WITH THE CROP TOOL

• Click on the crop tool in the tool bar to select it.
• Move your pointer on the image to the top lefthand corner of where you want to start the crop.

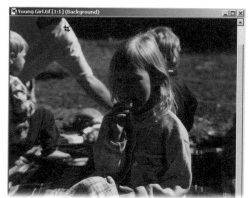

• Press and hold down the left mouse button while you drag out the cropping box to surround your main subject. Don't worry about getting it exactly right first time – it is easy to adjust.
• Once the box surrounds your subject, release the left mouse button.
• To adjust the edges of the box, move the pointer over its border – the pointer will change to an arrow.
• Now click and drag the edges until they are exactly where you want them.

The final cropping box around the subject •

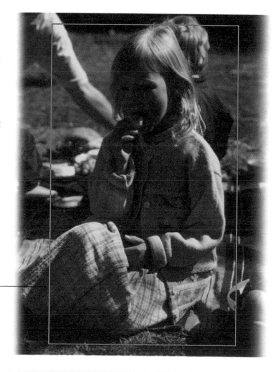

• To crop the image, select Image from the menu bar by clicking on it.

• Select Crop from the drop-down menu, and the image outside the crop box disappears.

Other ways to crop
To complete the crop once the area has been selected, you can hold down the Shift key and press R, or double click inside the crop box.

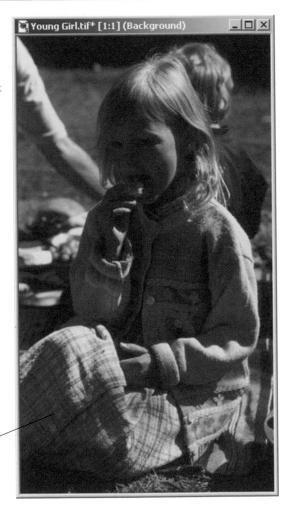

The final cropped image •

2 USING THE SELECTION TOOL
The crop tool is limited to just selecting a box shaped area. By using the selection tool, you can choose to select a square, rectangle, ellipse or circular area. You can also choose to "feather" the edges of your selection.

• Choose the selection tool from the tool bar ▯ and bring up the Tool Options window ▯ if it isn't already open on screen.

43 **The Paint Shop Pro toolbar**

42 **The Paint Shop Pro window**

• From the Tool Options window, select the Selection tab and choose the shape you want.
• If you'd like your crop to have fading edges, increase the feather width from 0 (hard edges) to the size of border you would like.
• Mark out your cropping area by pressing and holding the left mouse button and dragging the pointer until the shape is the right size. For circles and ellipses, position the pointer on the center line of the desired crop.
• To crop the image, select Image from the menu bar by clicking on it.
• Select Crop from the drop-down menu, and the image outside the cropped area disappears.

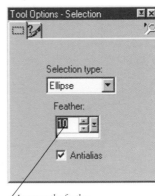

Increase the feather width to fade the edges

In this case, the oval shape has been chosen as a cropping shape •

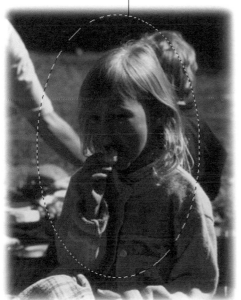

The final feathered or "vignetted" image •

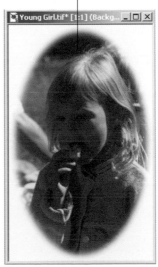

COLOR LEVELS

In Paint Shop Pro the easiest way to adjust the color levels is to split an image up into its component parts. This gives three grayscale images, separating the red, green, and blue parts of the picture. You can then adjust the levels within each separately and then combine them back together to form a full-color image again.

NEED FOR ADJUSTMENT

Taking a picture under different lighting conditions can affect the colors of an image 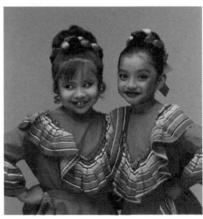. Fluorescent lighting gives an overall greenish tint and indoor lights tend to give an orange hue to everything. Also, some CCDs pick up certain colors better than others. By adjusting the levels of red, green, and blue within an image, you can make the picture look more naturally lit.

The original image
The image appears a little too dark and the skin tones are not quite right.

1 ALTERING THE COLOR LEVELS

• Load your image and click on Colors in the menu bar.
• From the drop-down menu select Channel Splitting.
• Now select Split to RGB.

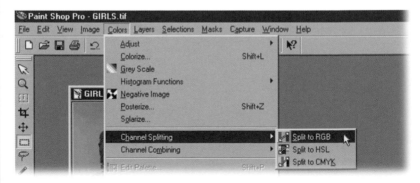

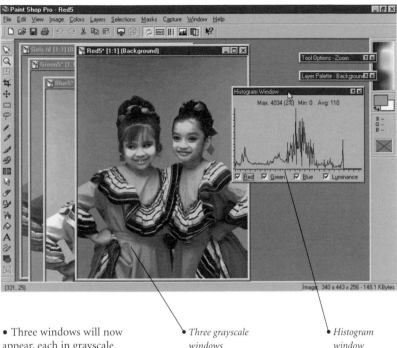

*Three grayscale
windows*

*Histogram
window*

• Three windows will now
appear, each in grayscale.
Bring the red component
to the front by choosing it
from the Window menu in
the menu bar.
• If you don't have the
histogram window
displayed on screen, open
it by clicking on its icon in
the menu bar.

• The histogram will show you the spread of red within the picture. In order to even up the spread of color, select Colors in the menu bar, Adjust from the submenu, and choose Highlight/Midtone/Shadow.

• Move the Shadow slider to the right to bring the color spread into the lower regions of the histogram.
• Repeat with the Highlight slider for the higher region.

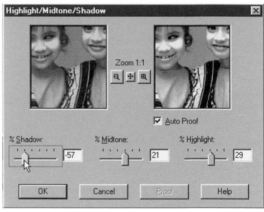

• Select the green and blue windows from the Window menu and repeat the same process for each of them.
• To recombine the three components, select Colors from the menu bar, then Channel Combining from the submenu, and select Combine from RGB.

• A new window will open with your adjusted picture in. If the levels aren't quite right then close it, adjust the components again and reselect Combine from RGB… until you're happy with the results.

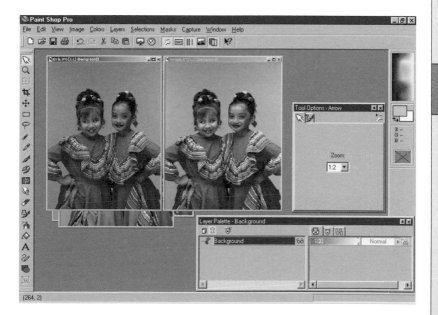

Before and after
The original image on the left was very red. Now it has more depth to it, the background is lighter and the girls' skin tones are more lifelike.

SPECIAL EFFECTS – ADDING TEXT

Once you have an image looking the way that you want it, you might consider using the image in a particular way. It may become part of a Web page or another of your documents. It could be sent as part of an email. If the quality is good enough you may want to print it in a large format.

In many instances you may want to include text over or within the image. Here we show you how to add text, and then how to give the text an exciting chrome look. The first example that we have used is simply adding greetings to an image to make a birthday card.

1 SELECT THE TEXT TOOL

• Using the mouse pointer, select the text tool from the toolbar by clicking on it.
• Again using the mouse pointer, choose the color you'd like to use for the text from the color palette at the side of the screen.
• Now click on the image where you want the text to appear.

Fonts
There are plenty of exciting fonts available on the Internet. Try www.free-fonts.com or look for "free fonts" on various search engines. Using an interesting font can add a lot more impact to the message you're trying to convey.

Choose a color from the color palette •

2 CHOOSE THE FONT PROPERTIES

• The Add Text window will now appear. Scroll through the options to choose the type of font you want to use, its style, size, and alignment. Click on your choices to select.

• Click on the Floating radio button in the Create As section of the window.

• Select your previous color under the 'Text Effects' section by clicking on it.

• Type in your text.

• The text appears on your image as floating words that you can move around.

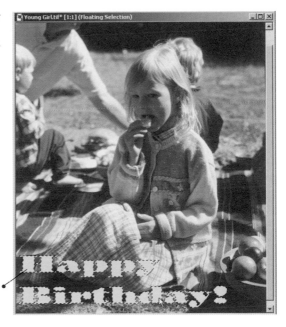

Floating selection

3 FIX THE TEXT IN POSITION

• Once you have positioned the text where you want it on the image, move the mouse pointer to the Selections menu and click.
• From the drop-down menu, choose Select None and click on it to paste the text in position.

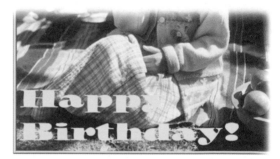

4 ADDING A CHROME EFFECT

• Create text by following steps 1 and 2 above, but don't deselect it (step 3).
• Choose the paintbrush tool from the toolbar, go to the Control window to set a small brush size, and set the color to black.

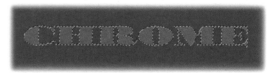

Paintbrush tool

• Draw a thick, wavy line right through the middle of the text. Don't worry about painting over the background – you can't! While the text is still floating, you'll only be able to draw inside its edges.

• Choose a light green color, increase the brush size a little, and draw another line below the one you've just drawn. Make sure it overlaps slightly.

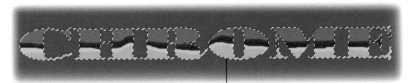

• Using the same brush size, repeat the same process twice more, but with two slightly darker shades of green.

Don't worry about going over the edges when you paint. While the text is still floating, you can only draw within the dotted lines

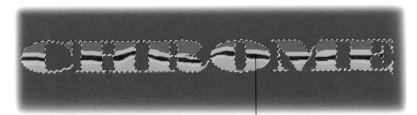

• Now choose a light blue color and draw a line above the black center line, again overlapping them.

Choose a light blue

• Again, do it twice more with lighter shades of blue to achieve the final effect. You can now deselect the image (see step 3) and the lettering is finished.

SPECIAL EFFECTS – SEPIA TONE

So far we have been manipulating the image to get the best results from your pictures, by cropping the image down to the area that we want to show, and by adjusting color levels to produce a good-looking image. Now, with the power of your image editing software, you can take it a stage further and enhance your pictures with the use of some special effects. The term may suggest extreme changes like turning your subject's skin color to blue or adding a couple of extra eyes but, while these can be achieved, special effects can be subtly applied to enhance the image. Black and white pictures printed on photographic paper slowly discolor as they get older. The same effect – called sepia tone – can be achieved with the use of dyes but it's a lot quicker and less messy doing it digitally.

1 ADDING SPECKLES TO THE IMAGE

• To begin the aging process, select Image from the menu bar at the top of your screen.

• Select Noise from the drop-down menu and then select Add.

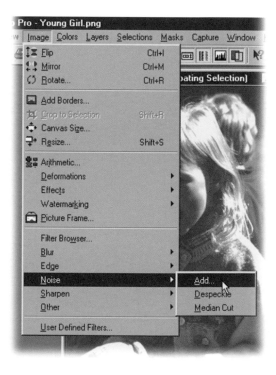

• From the pop-up window, choose to add "uniform" noise by clicking on the radio button.
• Set the slider to 25% and then click OK.

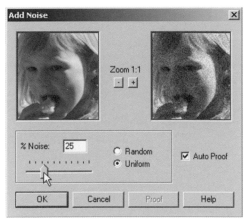

2 ALTERING THE COLOR LEVELS

• Click on the Colors menu and choose Grey Scale from the drop-down menu to remove all the color information.
• Now select the Colors menu, go to Increase Color Depth on the drop-down menu, and click on 16 Million Colors to turn it back into a 24-bit image.

• Bring up the RGB adjustment panel by selecting Adjust from the Colors menu, and click on Red/Green/Blue.

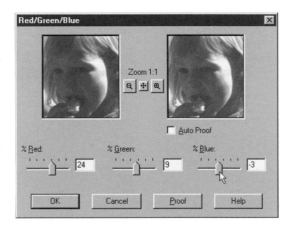

• Use the slider bars to set red to 24%, green to 9% and blue to -3%.

3 CONTROLLING THE EFFECT

• To further enhance the effect, go to the Selections menu and choose Select All. Alternatively, hold down the [Ctrl] key and press A to select all.

• To reduce the effect, select Modify from the Selections menu and Contract from the submenu. Enter a value of 10 pixels and press OK.

• To fade the border, choose Feather from the Modify menu, enter 10 pixels and press OK. Then choose Crop to Selection from the Image menu.

SAVING THE IMAGE

Once you've finished editing your image you'll want to save the changes. If you have plenty of disk space, you might consider retaining the original version you transferred from your camera as a backup should you ever need to revert back to it.

In this case you should save the image under a new name, or in a separate directory. This is also advisable if you intend to save your image in a compressed format, such as JPEG, that "loses" some information every time you save. If you open and edit a JPEG image several times it will degrade in quality.

The solution is to save your pictures in a "loss-less" format (see the guide to file formats ☐) that will retain all the information about your picture.

1 USING THE QUICK SAVE KEYSTROKES
• You can quickly save an image by holding down the Ctrl key and pressing S. This will write over the top of the original file, the version that existed before you opened it and made your changes, and it will use the same file format and options.

2 USING THE SAVE AS REQUESTER
• When you need more control over how Paint Shop Pro saves your image, go to the File menu and select Save As. Alternatively, press the F12 key on your keyboard.

• In the window that appears you can now rename the file by typing a new name into the File Name: panel.

• You can also choose to save in a different file format by selecting the one you want to use in the Save as type: panel.

Other file formats available to "save your file as"

• The Options button gives you further control over how the image will be saved. For TIFF files you can specify what type of compression you want to use and what color format to save in by clicking on the radio buttons in the Save Options drop-down menu and then clicking on OK.
• Click on the Save button to save the image.

SAVING AND STORING

There are many different ways to store an image on your computer. Each format has advantages and disadvantages, and it's important to know which one to use and when.

FILE FORMATS

In general, digital cameras produce images in the JPEG format, which has a high level of compression and allows many images to be stored in the memory. If you are going to be working on an image – saving and loading it several times – you should turn it into a format that won't degrade the overall picture quality each time you save it (e.g. a TIFF). Once you've edited your image, you should save a copy as a TIFF image – as a backup – and then save it in the best format for your purpose.

GIF (GRAPHICS INTERCHANGE FORMAT)

The GIF format is primarily used for displaying images from online sources such as the Internet. It only supports 256 colors, but has built-in compression to reduce the file size and can be used to add quick and easy animation to web pages.

JPEG (JOINT PHOTOGRAPHIC EXPERTS GROUP)

Popularized by the World Wide Web, JPEG is a highly compressed graphics format that is useful for photographs and other images where there is a lot of color information. It allows you to set a balance between image quality and compression.

SOME OTHER USEFUL FILE FORMATS

Listed below are a few more different formats in which you can save your files. The three-letter codes are the suffixes that will appear at the end of the file name. For instance, if a friend likes one of the images that you have taken but uses an Amiga, you could save the file as an IFF format, and send it to him or her. It may save a lot of trouble later.

	
CLP	Windows Clipboard
IFF	Amiga
IMG	GEM Paint
LBM	Deluxe Paint
MAC	Mac Paint
MSP	Microsoft Paint
PIC	Pic Paint
PSD	Adobe Photoshop
WPG	Word Perfect

PNG (PORTABLE NETWORK GRAPHICS)

Devised as an alternative to the GIF format, but for the same use – delivery of online images – PNG handles 24-bit images and allows you to have transparent parts in your image but with smooth edges. PNG images can be used in Web pages, but not all browsers support them.

UNCOMPRESSED

If you're after the highest level of quality that your camera can produce, then don't use any compression at all. While large images can take up 5MB or more, you won't have any problems with banding. As you might imagine, you're not going to be able to store many of these giant images on a small memory card and storage can be a problem.

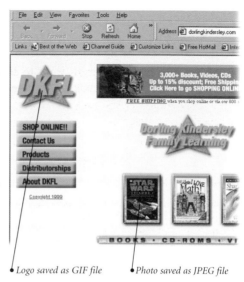

• Logo saved as GIF file *• Photo saved as JPEG file*

File formats in use
Here on a World Wide Web page we can see two different file formats being used for the purposes they serve best.

Format	Color Depth		Average File Size in kilobytes (800x600 image using maximum amount of colors)		Transparency
	Minimum	Maximum	Max Compression	Max Quality	
GIF	2	256	180	248	Yes
JPEG	16.8 million	16.8 million	25	361	No
PNG	16.8 million	16.8 million	620	944	Yes
TIFF	2	16.8 million	761 (compressed but no loss of quality)	1413	Yes

This reference table shows the capabilities of each format and how much disk space an image will take up (using various compression methods).

STORING AND COLLATING YOUR PICTURES

Once you've spent some time with your digital camera you will be collecting quite a mass of images on your computer. You probably won't want to keep them all on your hard drive, as they will take up space. One option is to clean up by deleting images you're not interested in keeping; but these images will be lost to you forever and you run the risk of removing a picture that may be useful in the future. The other option is to back your images up onto some kind of external media.

ZIP AND JAZ DISKS

These high capacity disks work like conventional floppy disks but require a special drive that plugs into your computer. ZIP disks can store 100MB or 250MB, and JAZ disks can be either 1GB or 2GB, depending on your drive.

Zip and Jaz disks

Optical disk and DAT tape

OPTICAL DISK AND DAT TAPE

Although they require special drives, these devices are ideal for backing up large amounts of data, as they can store several gigabytes for a relatively low cost. However, writing and reading tends to be very slow and only suited for clearing a lot of data off your hard drive at one time.

DVD AND CD

Compact Disks are relatively cheap, you get a very reasonable amount of storage space, the disks can be read on almost all PCs, and you can read information off them quickly. Digital Versatile Disks offer even more storage space but the disks and the hardware tend to be expensive, at least for the time being.

DVD and CD

KEEPING TRACK OF EVERYTHING

When you need to retrieve an image that has been stored away, the last thing you want to do is search through dozens of disks or directories trying to find the picture you're looking for. The secret is to keep your archive of pictures as well organized as possible. Depending on what kind of media you are storing your pictures on, different methods may apply but the principles are the same – either rename your pictures with meaningful file names and/or create plenty of subdirectories so you can catalog your images by their content.

Clear and simple
In this example, the directories have been named in such a way that the right image can be quickly located.

```
Browse - C:\My Documents\My Pictures

⊞ My Computer
⊞ My Network Places
   Internet Explorer
⊟ My Documents
  ⊟ My Pictures
    ⊟ Travel
      ⊟ America
        ⊟ Arizona
          ⊟ Grand Canyon
              By Foot
              By Helicopter
          ⊟ Petrified Forest
              Fossils
              Painted Desert
            Scenery
            Wildlife
        ⊟ New Mexico
            Carlsbad Caverns
          ⊟ Gila National Forest
              Cliff Dwellings
          ⊟ Santa Fe
              Buildings
              Sculpture
            Scenery
            White Sands
            Wildlife
```

NAMING YOUR FILES

When you transfer images from a digital camera the files tend to have names such as IMG0057.JPG, which doesn't really convey anything about the contents of the image. Try to develop a standard naming system so you can get a pretty good idea of what the image contains.

Above is an example directory tree that shows how you might break up a series of vacation pictures. Don't make endless amounts of nested directories that only contain one or two pictures each – the key is balance. If you have five or more images of a specific subject then they would benefit from their own directory.

IMPORTING INTO APPLICATIONS

Depending on what software comes with your digital camera, you may be able to import stored pictures directly into applications without first having to copy them over to your hard drive. This is quite simple to do. Connect your camera to your computer and then use a software interface known as TWAIN ▯ to read the data from your camera straight into a document as though it were a scanner.

IMPORTING INTO A WORD DOCUMENT

• In the Word document, place the cursor on the page where you want the picture to appear and click the left mouse button.
• Click on the Insert menu, choose Picture from the drop-down menu, and then select From Scanner.

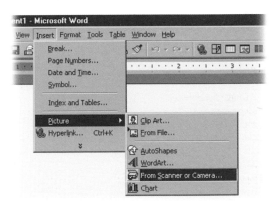

• The TWAIN interface will appear allowing you to select the image you want to import.
• Once you've selected your picture, it will appear inside your document.
• You can now adjust its size by clicking once on the image to bring up its drag bars (the small dark squares) and dragging them until the image is the size that you want.

39 **Downloading the images**

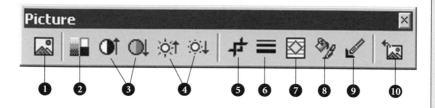

THE WORD PICTURE EDITING BAR

When you select a picture inside Word, a small window opens offering you options that enable you to do some rudimentary image editing.

1 Import New Image
Replaces the current image with another one.

2 Image Style
Makes the image appear gray, black and white, or as a watermark.

3 Contrast
Increases and decreases the contrast.

4 Brightness
Increases and decreases the brightness.

5 Crop
Allows you to cut away parts of the image you don't want.

6 Border
Adds a border to your picture.

7 Text Wrap
Lets you specify how text will be wrapped around the image.

Right: Text wrapping

8 Size/Position
Allows very precise control over the size and position of the image.

9 Transparent Background
Specifies a transparent color within the image so any occurrence of that color will show the document below.

Now we have made the image's background transparent, the text will wrap around the picture automatically!

10 Undo
Resets all changes you have made to the image.

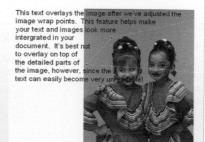

This text overlays the image after we've adjusted the image wrap points. This feature helps make your text and images look more intergrated in your document. It's best not to overlay on top of the detailed parts of the image, however, since the text can easily become very unreadable!

GLOSSARY

APERTURE
The adjustable hole behind the lens that controls the amount of light getting through to the film or CCD.

CCD
A light-sensitive chip that can turn light into a digital signal, which your camera processes into an image.

COMPRESSION
Whilst they come in a variety of "flavors", all compression algorithms reduce an image's file size without cutting down on its resolution.

CROPPING
Cutting out a subsection of an image, discarding the rest, to improve the picture.

DEPTH OF FIELD
The range of focus within a scene. A large depth of field means that objects both near and far from the camera will all be in focus.

EXPOSURE
The degree to which the film or CCD is exposed to the light when you take a picture. This depends on the aperture and the time the shutter is open.

FLASH
A very bright light that can illuminate a scene when you take a picture in conditions where there wouldn't normally be enough light.

FOCUS
By adjusting the distance between the various lenses within a camera, you can make objects sharp (in focus) or blurry (out of focus).

HISTOGRAM
A graph that shows the amount of red, green, and blue color within an image.

INFRARED
Light that is outside of the visible spectrum, used by some digital devices to communicate with each other without the need for cables running between them.

LENS
A piece of shaped glass that focuses light onto the film or CCD inside your camera.

LCD
Liquid Crystal Display, a small, low power display on some digital cameras, used to preview or review the images you take.

MACRO MODE
Allows a camera to focus on an object that is only a few centimetres away from the lens.

MEMORY CARD
A removable RAM chip on which digital cameras can store pictures.

PANORAMA
A wide-angle picture either taken using a special lens or built up by joining several images together in an image editing program.

RAM
Random Access Memory – allows digital devices to store information temporarily.

RED-EYE
The optical effect in which eyes glow bright red in an image, caused by light from the camera's flash reflecting off the retina at the back of the eye.

RESOLUTION
The size of an image measured in pixels.

SERIAL LINK
A basic means of connecting devices to your computer. Well supported, but now increasingly superceded by USB.

SHUTTER
The part of a camera that opens briefly to allow light to reach the film or CCD.

SHUTTER SPEED
The length of time for which the camera's shutter stays open when taking a picture.

USB
Universal Serial Bus. A recent, and very fast, option for linking digital cameras, scanners, and a wide range of other devices to your computer, allowing the rapid transfer of information between them.

VIEWFINDER
Eyepiece that allows you to frame your picture by showing you what the camera's lens will see when you press the shutter release button.

ZOOM
The effect of moving closer to your subject achieved by adjusting the distance between lenses inside your camera.

INDEX

ACKNOWLEDGMENTS

PUBLISHER'S ACKNOWLEDGMENTS
Dorling Kindersley would like to thank the following:
Paul Mattock, Peter Anderson, and Ian Whitelaw for commissioned photography.
Jasc Software, Inc. for permission to reproduce screens from within Paint Shop Pro.
Nikon UK, Canon UK, and Sarah Noakes at Jessops, Brighton.

PICTURE CREDITS
Telegraph Colour Library p.32; The Photographers Library p.20.